Ark House Press

arkhousepress.com

Where MSG is listed, this is quoted from The Message Copyright by Eugene H. Peterson 1993, 1994, 1995, 1996, 2000, 2001, 2002. Used by permission of NavPress Publishing Group, All rights reserved. Represented by Tyndale House Publishers, Inc.

Scripture quotations marked TPT are from The Passion Translation. Copyright 2017, 2018 by Passion & Fire Ministries, Inc. Used by permission. All rights reserved. ThePassionTranslation.com.

Cataloguing in Publication Data:
Title: A Forgotten Art
ISBN: 978-0-6450375-0-0 (pbk.)
Subjects: Poetry; Inspirational; Women's Interest;
Other Authors/Contributors: Brill, Bekky

Preface

My little existence may not mean anything to anybody but the One who formed me, my writing will never stand the test of time, for everything as we know it is fading - but if I can help your blooming heart be led to the land where forever is laced into everything that is and budding flowers leave kisses upon your precious cheeks then I have served my purpose.

Life is found when life is lost, and comes at a very great cost: when one is willing to lay down all sense of right, all sense of ownership and fearlessly throw oneself into the dazzling arms of He: He who speaks to the wind that you do not see yet somehow gives you oxygen, He who tells the sun to kiss the moon so we may have light in the night, He who grants to each of us the ability to feel, to taste, to touch, to love, to choose - to choose, even knowing that we may never choose Him. He is worthy of my little life, of my little words both of which serve no good at all if they do not blaze for you a trail to the place where the dandelions sing and the mountains bow and the blue birds fly with you. It is the land where many call heaven, and I, I call it home.

Welcome to A Forgotten Art if you are malleable and willing, this book may well change your life. Hear the Wind as He speaks, feel the Sun as He shines and, should you feel audacious enough, let your heart roam naked in these pages.

"With raw and authentic courage, Bekky has given a gift to the world in this book of poetry. We have had the joy of being in Bekky's life for some years now, and can testify that she lives a life of radical openness and true love for life and people, that is reflected in the language of this book. She lives what she writes, and causes others to do the same!

We feel this book has a hidden power within it's pages. This power comes from the faith of an author who knows that the creator of the universe is with the reader, ready to draw more freedom, comfort, connection and courage out of each person who reads these poems. Whether reading about honouring our bodies, speaking well, finding peace and seeking more help in community, we were moved to tears, inspired, encouraged to be more true to ourselves, and wanted all our friends to read this book.

A Forgotten Art is a must read!"
- Mark and Christine Greenwood

"I was incredibly touched by this creative, empowering and inspiring book. As a woman pursuing a career in music, in an industry where there are plenty of strong, opinionated men, it can be hard to find your way.

This book gave me a beautiful perspective on what it is to truly love myself, my body and my essence. Bekky's poetic voice resonates truth, acceptance and love."

- Emily Brimlow

A FORGOTTEN ART

Bekky Brill

Table of Contents

Dear Reader,

At this present time you are possibly sitting down, who knows, maybe in a cafe with a cup of tea by your side, maybe you are on your two feet, walking this earth that hosts you, or maybe, you are in the solace of your bedroom, laying upon the pillow that has nurtured a place for many of your night dreams to occur.

Where-ever it is you might find yourself in this dainty world, you have, for some bizarre reason, found your precious human hands holding onto this temporal book, its words, for whatever purpose, intervening your world.

This phenomenon that we call life may indeed have you in any kind of circumstance, maybe bad, good, mundane, or absolutely thrilling. At its best, or at its worst, it is definitely not one that any of us were prepared for.

May what you find within these pages permit you to understand, all the more, what it is you are truly made for; reminding you who you truly are, especially in this world where we are diagnosed with definitions for what we wear, how we act, or how we feel - some labels that we indeed place upon ourselves.

May the words that you find unlock the greatest longing of your heart, empowering you to harness the forgotten arts.

Yours Momentarily,
Bekky Brill

Please, remember, that we all need help...

...even the strongest of us.

Part I

A Forgotten Art:
Honouring My Body

Dear Reader,

I am certain that you know how it feels to despise the body that hosts you or treat it as though it is worth just as much as the trash that sits in your garbage. At times, it will depend on the day, the hour, the tan, the amount of likes your photograph receives or the kind of words you have heard and contemplated. To be quiet frank, with this state of mind your personal value depends on rather feeble conditions. It need not be this way, it need never be this way again. Have you ever pondered why you allow such disgusting reasons determine how beautiful you are at a certain hour, or whether or not you allow a man to fondle with your precious temple, even though you do not love or are not married to him?

I write to you as one who has been in just this position one too many times - in hope that it may free you or give to you the wisdom that I never had, but have now, to some great extent, attained.

I once looked in the mirror and would pick at any little flaw that I possibly could, I would pick and pick and pick until all that was left was great damage, and that damage, as years passed, only grew. Then one day, actually, over the series of many days I began to see that I was beautiful, truly beautiful: I yielded my ears to listen to His words and all I could hear was kindness - I decided that I would believe Him. What followed when I beheld my reflection next is that I would sit in front of the mirror weeping because I saw myself, body included, as pretty for the very first time and when it came to seeing my value I realised that it was never made for the swine.

This chapter is for those who desire to honour their body, an art that too little of us know how to do; an art that I am certain you are capable of harnessing. Read on if you dare, but do read on with a tender heart, for what good is any beating soul, is any flesh and bone void of a willingness to alter and grow; to refashion and glow.

Yours Momentarily,
Bekky Briff

Words I Spoke When I Hated Myself

Looking at you
And how you do not do,
I do not like to look at you.
This reflection I see
Staring back at me
With lashes that are not long,
Not long enough for me.

Looking at you,
I hate looking at you,
Looking at how you do not do.
You are not good,
You don't look as you should.
I must turn you into someone else,
So I can quit hating myself.

To My Body

I'm sorry I've been so hard on you.
The world spoke too loud,
for too long,

I see your beauty now.

Listen Now

With my eyes
I look upon my body
That I had always loathed
And I say to her
My beautiful body
Through poetry and prose
That my words
My little words
They do not hold the right
To tell you
You're not enough
Or you're an ugly sight
So pardon me
Please beautiful body
While I give Love the mic
Hear His words
Hear what He says
For what He says is right

The Day I Realised My Value

No longer is my body a toy,
a place of satisfaction for confused boys.
For my body in all its worth,
was never created to be treated like dirt.

To The One Who Says She's Missing Out

Could it be that all along you never lacked a thing?

Beauty

"There are curves in places they just aren't supposed to be," the me of my youth looked in the mirror and spoke to me, "why can't I be thinner, my boobs be smaller, why can't I look better?"

In the perennial questionings and my inability to fit into my friends jeans I decided that my shape is not something that deters my charm.

My curves, once the landing pad of abuse, now the resting place of Love and kind words.

I am no uglier than he, nor she, "you are beautiful," Creator whispers to me.

Now I can see what it is I've always had,
beauty.

Lovelier

"You are lovelier than all of creation,"
He said to me,
"lovelier than the birds, the bees, and the sunflowies."

Words Spoken

I must not look to myself and bring myself down,
for it is my voice that I hear the most inside my head.

Be Yourself

I was told when I was a girl that in order to be a woman I must shave the hair that grows on my legs and under my sun-kissed arms, I must always wear make-up and pluck the hair that's out of place on my brows. As much as I tried, the alterations never looked good on me. I was a sun-kissed flower made with the intricacies that were always meant to be enough for me. How silly it felt for me to try and change who I really am. I can not hide these flaws any longer, or the pimple on my chin. I can not hide the curve of my hips or the stretch marks on my skin. I'm far too lovely to hide myself.

Ugly

The problem was not that I was ugly,
it was that I let the world convince me that I was.

Worth Everything

Do you know it matters? If your body is given to a million men to
lay, if you drink a thousand bottles to make the sorrow go away,
if you commit a hundred rebellions in just one day. For your body
is not a play thing to be treated as if it is worth nothing - it is
worth *everything*

Value

I was taught that sex meant *nothing*
and my body was for pleasing men;
then I realised my value.

Weaved

I weaved a thousand words into her heart
to tell her that she is art.

No Lack

From the womb unto my youth my hips did not curve, my jaw was not chiseled, my brows had not much hair. From the womb unto womanhood, my teeth were not straight, my booty not plump, my figure unrefined. From the womb the Artisan wove me together - how could I dare point at the flaws that aren't actually there?

Gracious

Hear your words as you speak them,
are you gracious with yourself?

Golden Man

The golden man held my hand,
Led me where I had not been,
Took me to the far away land;

Where eyes could see all over again,
Again and again hearts could dream,
The golden man held my hand.

I can now stand when once I ran -
An art on earth that is seldom seen.
Oh, what help is this far away land.

Fear flew far away in that far away land,
So far that it is now unseen,
My hand still held by the golden man.

A second chance, a start again
A realm of life, a dream of dreams,
I found myself in that far away land.

This is far more grand than I had planned!
So here I am, a lovely scene.
The golden man held my hand,
Took me to the far way land.

Already

I spent a thousand years *trying* to make myself beautiful,
instead of learning to see that *I already am.*

You're Beautiful

Would you
look at your body for me,
your legs too?
You've been making fun of your shape lately,
but I think *you're beautiful.*

Adorn

I may adorn you
in a million white roses,
in the finest clothes.

I may trim and slim
to try and make you look good,
spend my time on you.

But sweet dear lady,
I once heard, a while ago,
that beauty does come

not from what's outward,
but from the souls adorning.
Can you tell me now,

what makes your heart sing?
Who is it that you breathe for?
Can you let go now

of beauty standard?
I hear Love calling your name,
come, let Him show you

what He sees in you,
what your life's really made for -
He brings clarity.

The Heavy Coat

At once he took the coat from my shoulders,
he took it off and laid it upon nothingness -
the place where I knew it always belonged.
This coat bore the weight of grief, of madness,
of places that I wished I never went.

This coat of stone that arched my back a little too far forward,
at last, has done away from me.
I now see things that I'd never seen when I was down there;
almost looking at the world from birds eye,
the air is cleaner up here, the load is lighter.

You

There are things in this world that are
beautiful beyond measure,
and then there is you!
I can't even begin to express your beauty,
I don't think I ever could.

Own Way

We are each pretty in our very own way,
don't rob yourself by thinking you are any less.

The Conversation

Have you seen my reflection lately?
I am so horrendous, it is ghastly!
How can you bare to look at me like this?
I can't even bare looking at myself.
Why can't my hips be a different shape?
If only my eyelashes were longer.

I'm fatter, I should exercise longer.
My, have you seen my thighs as of late?
They are touching! I am so out of shape.
Will I ever stop looking so ghastly?
I don't know why, I just hate myself.
It's so hard, waking up looking like this.

Am I the only one who feels like this?
My hair is too short, it should be longer.
How much longer need I look at myself?
Have you listened to yourself as of late?
How you speak of yourself is just ghastly!
Your beauty is not defined by your shape.

Who convinced you that you had a bad shape?
What is a nice shape? Can you tell me this?
And who said your reflection is ghastly?
Why do you want your eyelashes longer?
Who have you been listening to lately?
They have fooled you into hating yourself.

I ask, is your own enemy yourself?
If not, then why must you pick on your shape?
You've been so hard on yourself as of late.
You don't need to spend your life like this,
These cruel words need not last any longer.
For what this does to your heart is ghastly.

You loathing yourself is what is ghastly.
You may hate the reflection of yourself,
But I won't let this cripple you longer.
There is no flaw I see in how you're shaped,
There's only that of which you say there is.
Have you thought about your beauty lately?

No longer need you call yourself ghastly,
For lately you've been too cruel to yourself.
Your shape is beautiful, just as it is.

Undress

You undressed her like a letter,
as though her body were a package,
to make your body feel better.

She should have known better,
than to treat her temple like garbage
to make your body feel better.

Shame only grew fatter,
fat enough for one to touch,
when you undressed her like a letter.

A letter bound for disaster,
for of her value she had no knowledge,
only to make your body feel better.

This time I will teach her,
teach her how to take courage,
to not let you undress her like a letter.

For it's a waste of her virginity
to just let a man touch her,
to undress her like a letter,
to make his body feel better.

Virgin

Losing your virginity does not make you cool.

My Virginity

Would you be brave and strip me bare today?
I heard I hide, naive of what's out there.
They say that this is what big girls should do.

Open my eyes to find your undressed too,
it's dark, it's night, I must become aware,
would you be brave and strip me bare today?

They tell me many steps to sway their way,
they tell me how to fit inside their square,
they say that this is what big girls should do.

I mend, I bend, appropriate for you.
I shake, I twist, between my legs you glare.
Would you be brave and strip me bare today?

I'm tired, I'm bored, this is absurd I say,
there must be more, a better love affair.
They say that this is what big girls should do.

Barely a pearl is found with swine or shoe,
at this I turn to God, with Him I share,
would you be brave and strip me bare today?
I know that this is what big girls should do.

Wait

YOUR
VIRGINITY
IS
SPECIAL
(you'll be glad you waited)

Honour

In the end, when time has passed, I will remember most the parts of my life where I was able to honour my body.

Brand New Eyes

I could not believe how lovely I looked
as I beheld my reflection that day -
it's as though someone gave me brand new eyes.

For I could not see the ugly I once
saw; I could not see the ugly at all.
I could not believe how lovely I looked.

My touching thighs so beautiful to me,
my imperfect teeth - perfectly in place.
it's as though someone gave me brand new eyes.

For the first time in my life, I did not
pick her apart - the girl in the mirror.
I could not believe how lovely I looked.

I cried when I saw her, that pretty girl
that was me, she was just so pretty.
It's as though someone gave me brand new eyes.

It all started when I listened to Love
and let His words sink deep into my heart.
I could not believe how lovely I looked,
it's as though Someone gave me brand new eyes.

Dear Reader,

I know it can get hard when it feels as though this world can demand for us to look a certain way when our bodies do not know how to bend that way, or slim that way, or change in that way.

Which is why there is such a profound importance in learning the art of honouring your body - your body that is not just a toy, or a boxing bag made to take the punches of your cruel words.

The reality of it is, we live in a world where being sexy is worshiped in such a repulsive manner - I am speaking of the way that 15 year old me wanted to push up my breasts and show off my booty for the eyes of men. I had no sense of self-respect. When my now husband first placed his hands on my legs, he called them precious, and I remember crying because I could not believe that somebody thought my legs were precious - I, myself, was not even convinced that my own legs were precious. I thought that they were just something that had to look a certain way to be pretty enough.

To all of you ladies who are reading this page, your body is precious - encompassing beauty that not just any man deserves to touch. I hope that even right now you would begin to see such value in your body, your beautiful body.

I hope that you do not blame anybody else for the way that you see yourself, for yes, there are ideas of beauty that are in the movies and social media. Yes, there may be people who call you fat, ugly, or not good enough. But at the end of it all, you are the one who gets to decide how it is you will see yourself. And by Grace, you will see just how absolutely ravishing you are (if only you will let yourself).

Yours Momentarily,
Bekky Brill

Part II

A Forgotten Art:
Speaking Kind Words

Dear Reader,

In order to nullify morbid speech and the filthy act of comparison, we must first realise, by Grace, that our bodies, as they are, are magnificence, never made to look exactly as another. I thank God that we are each uniquely formed, for how placid would this earth be if we all looked the same.

How our words are powerful - whether spoken to ourselves, to our friends, to strangers, to our children, to our parents, or to our leaders. Next time, when you speak, take note of how your speech directs a room, a conversation, a train of thought; it is rather frightening how powerful the sound that comes forth from your lips is.

I do hope, that to some extent, this chapter grants you the wisdom to be careful with your words. To forsake the horrendous act of gossip, of speaking in a manner that belongs in the pits of hell. For if you speak with words that belong down there, you surely will cast heavy stones upon yourself and upon those around you - all because you wanted to 'tell them how you really feel' - you might as well take a knife and stab them in their beating heart if you have the dirty courage to speak down on them.

As for comparison, that putrid type of criticism has no place in your life. It never did anything worthy of your attention, so don't give it your affection, your emotion, your state of mind. You may not be like her or he, in fact, you may never be but that does not make you any less, or any greater for that matter.

As you read on I hope that your mind would become so aware of the words that you speak from now on.

Yours Momentarily,
Bekky Briff

Comparison

We were not made for comparison.
For no womb has ever birthed two children that grow to be the
exact same,
aren't we all tired of playing this game?
Changing who we are to fit this box we all have made.
Take a look in the mirror,
can't you see you are made for beauty that was never meant to
fade.
We were not made for comparison,
for another you, there will never be,
don't rob this world,
this love hungry world,
of seeing the only you they will ever see.
We were not made for comparison!
Our legs, our breasts, the shape of our hips were not made to be
as another.
It's time we throw our swords to the fire,
for war,
against ourselves, against each other,
will no longer be our habitation.
We are not made for comparison,
we never were,
we never will be.

Content

My lips well seasoned with kindness,
my speech drenched in edification,
my heart content in all that I am.

See

What do you see when you see her?

What do you see when you see yourself?

Stars

A taste of the stars lingers on my lips
from *never* speaking down on you.

Changes

There are changes that occur when we place stars
instead of dirt upon our lips, there are changes that occur
when we *change* the way we speak.

I do, I do

If ever once or twice I could say to you
I do, I do, I see your value.
Too many times I was mean to you,
Too mean to tell you that really I loved you.
My flesh, my bones, my earthly home,
My hands, my hips, sweet body with lips.
To you, only you, to you I say,
You are lovely in your very own way.

Self-Love

By sun and candle-light, I speak kind words,
my own voice echoes itself as I proclaim,
"I'm pretty," over and over again.
Expectant that my own heart would have heard,
fallen for the words that my lips transferred -
to convince myself I am not ashamed.
But why does this not cause my fire to flame?
My claims must be in vain, this is absurd.

My own speech incapable to withstand
the voices that frequently deplore me.
Is it still strength to see my weakness?
For self-love did not go as I first planned.
I implore the Maker of land and sea,
to come to my aid, for alone, I can't do this.

Dirty Gossip

The immature often give voice to filth,
as their hollow words dance with poor judgment,
often oblivious to the damage
vile words can cause to the one who listens.
Do we not struggle enough as it is?
Are not the words in our head cruel enough?

We already know we're not good enough!
Our figure, atrocious; our face, filth.
Have you any clue how hellish this is?
We are scorned daily by our own judgement,
we, the ones foolish enough to listen;
our own lips caused us sufficient damage.

How have you the nerve to add more damage?
When will you discern enough is enough?
Do you hear what you are saying? Listen!
Would you like your daughter to hear such filth?
Would you place her under such poor judgement?
Do you see just how devilish this is?

Have you ever pondered how cruel this is?
You know how it feels to hear such damage,
when upon you was bestowed their judgement
and you reached a point where you had enough,
where you could not believe they'd speak such filth
about you to those whose ears would listen.

Yet, you mimic their callous, just listen
to the way you speak about who she is.
Your very own lips uttering pure filth.
Please, would you stray from causing such damage?
I don't believe our hearts are strong enough
to take the punches of such low judgement.

Who permitted you to cast such judgement?
What if her ears were present to listen?
Would you still engage with gossip? Enough
of your words could lead to sorrow, that is
bound to cause depression. Now this damage
you are *responsible* for is just filth.

May this be enough to defer judgement,
for such filth helps not the one who listens
it is mockery and damaging.

Sweet Child

Tormented by comparison you despise yourself,
sweet child,
I like how you look when you first awake,
before you recollect
all the things you think you are not.
I dare say you are not a mistake,
you can be yourself today.

Weapon In Words

Could it be that the words that fall from my lips
could steer, could turn the direction of ones life -
could steal, could give I must be kind with my speech.

I once spoke with my lips to a group of kids,
I told them to their face, "You have no value in this life!"
It could be that the words that fall from my lips

could steer, could turn the direction of these kids,
for these kids they took their life with a knife;
I stole life with my words! I must be kind with my speech.

I once told a grown woman, "you are ugly Miss,
you should change your lips to be a nicer sight."
It could be that the words that fall from my lips

could steer, could turn the direction of a miss,
for she changed her lips through surgery. A fright,
my words mocked her, I must be kind with my speech.

With my speech now cruel words I dismiss,
for life and death it rests in my little lips.
It must be that the words that fall from my lips,
could steal, could give I must be kind with my speech.

Adorn

So let the Creator of
heaven and earth
decorate your soul.
He is *better* at it
than you are.

A Choice

With your words you could paint a thousand tragedies *or*
a field of blooming heavenlies, choose wisely.

Power In Sorry

To confront the perceptions I have of you is
awfully frightening, to be willing enough to accept that my
thoughts toward you may be wrong,
that what I said about you was not
edifying and to gather the bravery to apologise
to you is incredibly *humbling*

Brilliance

Burn hearts with the *brilliance* that is you.

Together

Something was always missing in me,
a lacking no earthly good could fill,
always another she who has the better part of the deal.

They say You are the vine,
the One in whom I abide,
the One who gave my dry bones life,
and in this I find my delight,
I find myself,
my purpose in Your love.

And in this Divine I see myself,
this vine seeping into my cracks,
my hidden ugly,
and makes me *beautiful.*

You see, my sister,
I wearied my bones trying to be pretty like you
trying to be someone like you,
hating that I could not be you.
But sister, I need you,
I see you now, in all of your beauty,
and I see me in all of mine.

My sister, I love you, *I'm sorry* for ever comparing myself to you.
My sister, I am with you, at times I am weak too.

Messiah once said, "by this we know love, that we lay down our
lives for one another," so my life I lay down to you.

May I love you, and love you, and love you and never again speak
a word against you or against myself.

Kinder

Mockery and envy pervade us,
its false consolation births corruption.
Why must we let our tongues dance with gossip?

What if I put our words into a jar,
gave them back in a year that is far, would
mockery and envy pervade us?

Meet us with distress and invade our joy,
tell us of all the things we are lacking.
Why must we let our tongues dance with gossip?

Do you know she'd shine if we were kinder?
For our words sink deep. Why must we allow
mockery and envy pervade us?

Is it due to the lack of love we have?
Need we search higher to find a reason
why we must let our tongues dance with gossip.

May such idle speech depart from our lips
(if we want to help the world that is). For
mockery and envy pervade us.
Tell me, why must we let our tongues dance with gossip?

Boxing Lips

Boxing lips,
impetuously casting words about,
for the ears to catch,
for the mind to ponder.
Bruising the buildings of the heart
with careless expressions.

Daisy Heart

I spoke to her heart, as though it were a field of daisies,
consumed in absolute beauty. As I spoke, I saw the daisies
blooming, each one of them. I saw the daises gleaming, each
detail of them shining with great light. Oh, my words, my power
filled words, they brought her heart to life.

Veils

Who are these people, you people I walk by, I pass by?
With the glitter in their eyes they put there in the light of the
moon when no one was watching, no one was looking, in their
own attempts to shine. They are smiling, speaking with their
facades - their veil they hide behind, with the lies they keep
locked in the cellar, next to their unachieved dreams, their untold
fears, next to every single body in the world they've convinced
themselves they want to be. Who are you people with the stone
hearts and robot arms, mechanical arms? Under the spell of hell
as you proclaim your liberty while riddled in anxiety. Oh, the
disquiet of your heart. CLICK. Everything a life is built upon
disappears - if you look close enough to the ones who've died,
they've returned to dust.

Idols

You exhort yourself,
living as though your reputation is your god,
idolising how you look,
you eat,
you dress.

TAKE OFF THAT OUTFIT OF SELF-WORSHIP;
it never looked good on you.

Nobody But You

Take me to the base of your soul
where in this moment
you'd choose to be
nobody else
but you.

Wear You

Nobody wears you the way that you do.

Always

Long hair, short hair, frizzy hair, no hair,
always,
you are beautiful.

Differences

One must accept that we each are different, and that these differences do not make us greater or lesser than one another.

Temporal

I could heap all you own and burn it,
in a moment I steal all you know -
don't waste your time on the temporal.

Your money, your car, all that you are;
your clothes, your hair, the place that you work -
I could heap all you own and burn it.

You spend your youth focusing on this -
your booty, your lips, that one day sag.
Don't waste your time on the temporal.

One day, you too, will pass. Alongside
those that you love. So, why bother when
I could heap all you own and burn it?

Maybe we need see your deepest parts,
the you that lays beneath the facade.
Don't waste your time on the temporal.

Lovable girl, what is inside you?
What do you live for beyond yourself?
I could heap all you own and burn it.
Please, I beg, don't waste your time on the temporal.

Cardboard

Your clothes are so *fickle* you may as well wear cardboard.

Comparison

Shrink me into your desires, *tell me if I look good*, if my texture is
pleasurable enough for you. Girls like me seem to be *too
malleable* to mouthpieces like yours, too yielded. My voice it
does not know how to speak, my feet they do not know how to
stand, I will never be good enough for you. I do not know how to
be like you, in all of my attempts this mask that you have taught
me to wear just doesn't seem to fit. I am not she who is able to
dwell with something like you, *my body will not let me bend that
way*, my heart can not beat for the fickle, for the temporal. My
attention is too distracted upon the things that are pretty to pick
her apart. I hear you call her ugly, but I do not see with your eyes,
I can not. I just can not seem to keep my balance on this
pedestal you have placed me on. I am not better than all those
other humans, besides, *we are all made by the same hands*. My
goodbye may be far from subtle, but it is time that I let you go,
for *I can no longer dance with comparison.*

Someone Else's Skin

What happened to you, the girl I once knew?
Only the monstrous plea to fit in
As you try to wear someone else's skin.
How did you get in there? Did you use glue?
Do you think her skin looks better on you?
God forbid that you would fall for such sin.
What jerk fooled you into this? Was it him?
That voice that has nothing better to do

Than to fool you into thinking you lack.
That ass-wipe does not know what he's saying.
Within you I see a dazzling woman.
Now take her skin off, away with that mask.
You see, the real you is far more ravishing.
Soon, you will learn to love who you've become.

Shame

You say there's thousands prettier than you,
there even may be a million slimmer,
I'm sure there is plenty who are fitter.
You may as well hide yourself in a shoe
with all the shame comparison gives you,
for this burden will not help you *glimmer*.
You don't need to try to be like her,
there's just so many girls to compare to.

You must be exhausted in doing this:
comparing yourself to their beauty.
For it takes from you more than it gives.
May you *let go* of this tragedy,
so comparison may have its last kiss
for there is *no room* here for its cruelty.

Bad Changes

I wanted to be the girl you wanted,
so I changed the way I laughed,
I ate a little less,
I stopped listening to the music I loved.
Silly me,
being the girl you wanted
meant losing myself,
and becoming the girl I *wasn't.*

Words

Words,
how words are significant.
Not to be tossed around,
nor lightly spoken.
Words,
holding the power
to change the direction of ones world.
Words,
please be gentle with your words,
for they contain the power of life and death.

Lips

She coated her lips
in that of which
brings fields of blooming flowers
to those who hear.

The Vicious Cycle

May the vicious cycle of comparison and gossip end with you -

it *distorts* who we are.

Dear Reader,

I'm sure by now that you know full well the tiresome dwelling of comparison and gossip. I sincerely yearn that your heart and mind would grow such an intolerance to this type of pondering, this type of speech. That the end of this chapter would conclude comparison and gossip in your personal life.

May your lips offer only the words of edification to those around you, and also to yourself, for each of us know the insurmountable joy it brings the heart. May your mind only consider that of which is good, that of which is coated alone in nourishment for the soul. May your ears, ever so often, if not always, be inclined to the words of your Maker.

If your feet ever so happen to find themselves amid a conversation that encourages dishonour and appalling tittle-tattle may this be a reminder that you are consumed with the bravery and wisdom it takes to steer the course of that conversation to one that is absolutely and thoroughly drenched in good love and kind words.

Remember, your tongue is a powerful weapon, one that can destroy, and one that can bring life. Use your weapon as a woman of sheer excellence would, and extol the beautiful people who surround you, we need it more than I believe any of us truly realise.

"Kind words heal and help; cutting words wound and maim."
-proverbs 15:4 (MSG)

Yours Momentarily,
Bekky Brill

84

Part III

A Forgotten Art:
Peace Amid Chaos

Dear Reader,

What sorrowful and trying incidents take place here on planet earth. Each of us able to piece together many words of the trouble that our souls have thus far endured, or at times, been overcome by. However, an even greater pity I foresee, is that the blood of Christ would go to waste in these moments. That too many would busy themselves with the dolorous atrocities in life that they forsake the very companion of peace that we were granted to dwell with in these times, you know, the kind of peace that makes no absolute sense to have when taking into consideration the current adversities that confront us.

Needless to say, some pretty big stones can be thrown upon us at times, stones that have no care for our joy, our freedom or our peace, and it is in these exact moments that we get the sweet privilege of seeing what is really inside of us. I once read that dandelions can grow in the toughest of soil. Even the sun, as he shines, still shines no matter how dense the clouds are, no matter how wild the storm. That even you, on your most gloomy and darkest of days have a great Comforter near you, willing to help you should ever you seek Him.

It might not seem true, but by golly it is, that not even you, when you feel that no one is there for you, when you feel most troubled by the crazy that confronts you, when there is no foreseeable way out, that not even you are ever alone! That even for you there is hope, even if the crazy chaos never ends, even for you there is peace - peace that comes into your crazy and allows you to simply breathe, breathe.

Here is the chapter dedicated to teaching you, all the more, what it is to harness the winds of a storm as an eagle would.

Yours Momentarily,
Bekky Briff

Garden Soul

"Didn't you know?" he whispered to me, my knees on the ground,
face down, gravely in need, "the earth desires to hear your
garden soul beat to the melody of *no worries*."

Product

I am not a product of my circumstance, rather, of His love.

Adultery

When I was young I had been deceived that every man would
cheat on me.
I did not know what to do with the pieces of myself that no
longer knew how to trust,
no longer knew how to open my heart to the men who always
got my body but never got my love.
When they came too close my heart would run, lock itself in the
cellar before my body even realised what it was doing.
Young, I did not know what it meant to be a woman;
there was fear engraved in the deepest parts of me that would
tremble at the thought of trusting another man loving me.
Yuch! Get away from me!
Why did you look at her that way?
Why are you talking to her?
Who is that girl in that photo who is standing a little too close to
you?
Too many times my mind would ponder him with another,
deceived, I always believed it was the inevitable.
WRONG.
Not every man will cheat on me,
Not every man will take advantage of my vulnerable heart,
of my ability to love.
I trust my husband, it is a miracle from God.
I am no longer the she with those trust issues,
no longer the she that would question his every move.

So to the men, to the women, who had a bad example of what
it is to stay loyal; every second you press into God and let Him
teach you how to trust, how to love, how to let go of this past
that haunts you is a step closer you will take to trusting the one
He puts in front of you.

Your Garden

When I come to Your garden
I take all my clothes off
For I know you are not afraid
Of the weakest parts of me

Born Again

I am not the remnants of that dark city.
Of that town without sun, without hope
without any idea of how to really cope,
cope with the tragedy that unfolds here,
here on planet earth. I can not be
can not be, will not be miserable. I found hope,
hope took me through the kaleidescope
away from that city that can not host me.

I died in that city, came away born again,
born into the new me, the real me, the me
that speaks to the dirt and calls forth flowers;
the me that still rose after all that pain,
and gained a far greater reward: Eternity!
She devoured that city, dark city overpowered.

Serenity

Sweet child, play on amid the violent screams
that to you the unwelcomed chaos brings;
serenity she still sings in the storm.

She sings, still sings even when she's not heard,
awaits for your ears to find where she is;
sweet child, play on amid the violent screams.

When wet from tears and frightened by the fear,
know that she is near to catch every tear;
serenity she still sings in the storm.

She won't fade away with all of your bliss,
she will teach you to stand on your two feet;
sweet child, play on amid the violent screams.

While the violence screams she will help you rise,
but only when your eyes look to her skies;
serenity she still sings in the storm.

Distractions won't help you when you are down
for it's only white sound that numbs and frowns.
Sweet child, play on amid the violent screams;
serenity she still sings in the storm.

Misery Loves Company

Misery found me in the valley
when I had already dwelt with despair
misery came, wanting to consume me,
wanting to eat of me, of my flesh, my bones.
Misery had no care for me, did not care for me.
He did not care for my beating heart, my dreams,
my ambitions he seemed to want my company,
my attention, my affection but misery was no match for me.

Misery was not made for me, did not know how to dance
how to dance with me. Misery you must depart from me,
there is no room here for your jargon, for your nonsense,
you have no sense of who I really am, what I'm really made of.
Farewell misery, you have no place, you have no place in me.

Silence

Silence speaks of the heartache, of the weary years, of the unspoken tears you wept in the light of the moon. Pain came too soon for your young blood to comprehend what it means to laugh again. Take it from me, youth filled soul, Love will help you make sense of it all.

Baptism

I am not the final product of the terror I have experienced.
For I have sat at the feet of Mercy,
drank of the wine He gave me and feasted upon His bread.

Then He took me underwater,
that's where He revived me.
I breathe again,
my past a distant memory,
no longer something that holds me.

Confrontation

God is as real as your flesh and bone,
as your earthly home, He is just as much
human as you, just as much spirit.
So if ever you dare have anything against Him,
do not be as the foolish and hide away,
run away into your room, into your cellar,
rather, speak to him as a real human should,
as a real human would with another human.
Depart from egocentricity and dance with humility as you come,
come with open ears to the one, the only One,
whom you must confront. Bring to the front
what you cannot stand, what you don't understand about Him.
This is where maturity comes in, where you come to Him.
When you come to Him, come to speak to Him with honesty.
Only infants avoid confrontation.

Hallelujah

I heard her echo into the wilderness some distant hallelujah, hallelujah - it was far and faint. She was faint, nearly all dried up I swear, the desert must not have given her any water, yet her lips still yielded an impassioned hallelujah. If her heart were a stream I'd swear the desert would be an ocean - for the drought could not seem to steal the water from the well that is inside her. If I've never truly seen courage, I'd be sure I have now. Hallelujah. What God births such passion inside her? What Saviour is still worthy of praise for me to still hear her echo into the wilderness? Hallelujah, hallelujah - she has been in there, still there, singing for years.

Stand

I will not stand on the sidelines of my own life wishing that
somebody else would do it for me.

He Knows What You Need

You're not a disappointment! When the hammering words of yesterday's come to violate your very existence, remember the trauma has already been carried for you, that your mistakes have been forgotten, that your slate has been wiped clean. Beautiful, kind Jesus, He knows what you need.

Changes

If you want change, do not wait for the another day, for the right time, for the better feeling; do not wait for somebody else to tell you, to decide for you, to make you move. If you want change, you need to make the move, you need to be diligent, you need to quit playing the blame game and realise that you hold the power to create change.

Carried

In the absence of Love I met catastrophe, face to face, he ruined my place, tore apart my family, told me I was ugly, worthless, that my life had no purpose. Night after night I would ponder my escape, dream about tying a rope around my neck, or drown down deep in the oceans depths, I needed to escape. In the absence of Love I met misery, depression ran deep in my weary bones, I forgot what it was to have a home, my heart too familiar with being alone. In the absence of Love, I found you, Love, arms open wide. You had this ability to look past my former mistakes and gave me the ability to start again. "Hold on!" you said to me, my arms too tired, my body feeble from the heartache, so you came down and you carried me.

Dreamer

In the slumber of my melancholy I was approached with the decision to turn to the blooming fields of radiant flowers, or remain stagnant in the doom of my despair. I chose to bloom, for a dreamer belongs where the wild ones grow.

Religion

I fell for you for a day or two
You did not tell me how to move
Only to mirror you, you statue,
Rigid, rigid, rigid,
Did you forget what movement is?

I hear you say do not touch,
Do not taste
I hear you say, you say,
You say that my actions aren't enough!
What more need I do?

Need I tie myself as one of them
Toy dolls, lathered and laced in only the finest
For you, for you always say
Always say I need be better.
But better does not fit me,

Better does not free me,
Better does not know,
It does not know how to meet me.
Only accuse me of all that I can not do
I can not do enough for you.

Foreshadowed

In my boundless attempts of confidence
And self-ability amid the monsoon
I find my little soul foreshadowed by
the strength of a kind God.

Liberty

In His warm language of personal feeling,
sterile legalism swiftly diverges,
disarming self effort,
exposing the weakness of all of me.
God,
obliterating the mechanical spiritless parts of me.
Religion waving its own opinions as it is carried away by the dust
of the desert,
while the clay, that is I,
receives a stroke from the Potter,
an exhilarating touch,
to one in need,
to one who is weak,
whose desires this world no longer knows how to fill.
I am uncertain if there is sense to all of this,
that is,
how it is you come,
how it is you ask me to bend each day.
What I do know is this once vacant temple now hosts You,
God,
oh God.
I watch as my heart fears fold away into your blood.
How could I,
please could You teach I,
your bond-servant,
how to live a life worthy enough of the curse you became for me.

Joy Exists

It does not have to loot you of the joy
That is rightfully yours. I know they say
It will hurt, but joy exists in all things.

Joy lingers in the whispers of the wind
That laces itself around all that is.
It does not have to loot you of the joy

For it gives, but it need not take from you -
It only takes what you permit it to.
It will hurt, but joy exists in all things,

That is why streams still flow in the valleys,
And the light shines best in the dark of night.
It does not have to loot you of the joy,

Perhaps, this can be your way to fight back,
With gratitude of all that still is in life.
It will hurt, but joy exists in all things.

There is a gushing river of hope, here,
In the darkness, in the tremble - hope's here.
It does not have to loot you of the joy
It will hurt, but joy exists in all things.

Sun and Moon

I knew at once he must have been the sun,
and I, the moon, for his light made me gleam.
I was unaware that I needed him.

I was unaware that I was the moon,
for prior to him, everything was dark.
I knew at once he must have been the sun.

He brought out this kind of brilliance in me,
that I had not seen, that no eye had seen.
I was unaware that I needed Him.

How does moon reflect sun so perfectly?
My darkness did not even bother him,
I knew at once he must have been the sun.

Everything is so clear to me now,
I'm sure, before, I was moon without eyes,
I was unaware that I needed Him.

With new eyes I rise, as a dove that flies,
my insides electrified by His light.
I knew at once He must have been the Son,
I was unaware that I needed Him.

Pleasure

Dawn into dusk she slipped away, deep into the green surrounded by the trees, no one was there to watch her, no one could see her, no one knew what she was doing. In her solus she chose to dance with Dark Pleasure, only for a minute, she, convinced it would be okay so long as nobody would know, it would be her little secret.

Dawn into dusk, night came again, I searched deep into the green surrounded by trees, she was nowhere to be seen. Where did she go? Where did she go? Eyes search the earth to find her, she is found, wide open spaces surround her, the stars and moon shining upon her, she is unashamed with nothing to hide. She realised that it did not matter that nobody knew what she did, but what did matter is what it did to her soul, it made her feel worthless. She almost lost herself dancing with Dark Pleasure, good thing she had the courage to turn away.

Dusk into dawn, a new day greets her; her yesterdays drifted down stream, deep into the valley of forgiven. She slips away, this time, into the sun, True Pleasure greets her, asks if she will dance with Him. Since this day, I have not seen her. I heard that she is still in the sun, dancing with True Pleasure, some say that she was seen with Him, laying in fields of green, others say she's beside the still waters, basking with him in the sun that gleams. Needless to say she is free, the most free she has ever been.

Helper

My hands are empty, bearing no thing of great value.
My strength is weak, incapable of doing many things.
Your love is steady, able to carry.
In my helplessness your hand is reached out toward me,
seeking to help me in every way you can.

Exposing Addictions

The bondage left a trail of satisfaction
that one could not help but eat,
addicted to the melancholy that laced the soul with fear.
Better to feel something, than nothing at all, right?

Grief

I still remember the day you kissed the earth goodbye,
my heart wept.
I still remember the day I got to lie by your side,
my belly hurt from the laughter.
I still remember you,
on the kindest and hardest of days.
Having you so far away isn't easy,
but I know great Love carries me,
and somehow, everything will be okay.

When Overwhelmed

To be encompassed by emotion that would seem insurmountable is a tiresome dwelling. When awake, you are plagued by sorrow, when in bed, you struggle to find a companion in sleep. Amid the anarchy, One distinguished lingers among the turmoil patiently waiting for your eyes to find His. When found, solitude enters a once restless heart. Your circumstances, still identical. Your soul, absolutely at peace.

Playing In The Light

I found fear when I was young
I was eight, maybe eleven, playing.
I was playing, dancing in the light,

In the light on the road, when a big,
fast car came speeding toward me;
I found fear when I was young.

Screech, the sound of his breaks,
he was a man driving, middle aged man.
I was playing, dancing in the light.

The car it did not reach me, did not
touch me, but it gave me a fright.
I found fear when I was young.

I found Hope when a little older,
He called me daughter, banished the fear!
I was playing, dancing in the light

Hope looked a lot like light, actually,
I am rather convinced that Hope is light.
I found fear when I was young, now, Hope;
I am playing, dancing in His light.

Dear Devil

I do, I do, I do not need too much from you.
You lie, you break, you cheat, you deceive,
never, not once, to benefit me.
You treat me as a rat, as a mat, and I am through with that.
I do, I do, I do not need too much from you.
You belong in the pits, in the dirt, in the ground beneath my feet.
You belong in the swine! It is fine if you stay away from me!
I do, I do, I do not need anything from you.

Budding

Wipe the dust from your feet, cremate your troubles and throw
them into the Atlantic ocean. For you are divine, a sublime, a
phenomena; you are unparalleled in God's eyes. You can leave
your sorrows at the door, or on the floor, you can leave them
wherever you like, just not inside your mind. For your worries,
your fears, your mistakes, my dear, were carried upon the
shoulders, kind shoulders of Christ, who's always known what
your budding soul needs. So carry on wild heart, carry on in
romance and dance. Carry on with all your hair, carry on with all
your dreams, and if you have none, thats okay, for there is always
a way; a way that you'll love, a way that God will offer you on
every kind of day.

Honesty

Honesty is an art, an honour to the heart.

Conqueror

One thing I am sure of,
you're more of a conqueror than you realise.

Dancing Hope

Hope dances best in the twilight, deep into the night where no
eye can see the blue, where no sun can kiss the skin. Hope
dances best in the twilight, for when the turmoil dwells for a
time left untold, and all that is seen ahead is as far as just one
step - hope dances best in the twilight. For hope can easily be
found when all is well, but hope dances like no other when found
in the dark with no confidence of a way out. So in the mayhem,
may you find Hope, and let Him sway your dancing hips as
they've never swayed before; for we all know that hope dances
best in the twilight.

You Are Your Master's Slave

When the climax of the chaos hit
I was confronted by my weakness.
For nights now, I lay in bed sleepless.
Things are really hard, I must admit,
dark voices of the earth tell me to quit.
I do not know if I'm fit for this;
this episode that this terror is,
this terror that I did not permit.

Who permitted the chaos to harm me?
It's got me wrapped around its finger,
as I toss and turn in its heedless waves.
I have been at the mercy of its seas,
once care-free, now crippled by its torture.
What a disaster, I've become its slave.

Circumstance

Towers of happiness came tumbling down
because you built your life upon circumstance.

To My Mistakes

You came as a surprise deed that I did not know I would do, the one my flesh submitted to, ignorant that I would regret you. Confused as to why I partook of you. Shame: an unwanted gift you gave and in that shame I was repulsed by myself. Then upon me, great Love came, whose arms I did not know how to come to, whose arms, knowing what I did, still came to me. Forgiveness, is this what forgiveness is? You loved all of the shame out of me, like fluid it poured out of me. This Love makes no sense, no sense I can make of this; I am just a small, undeserving child in the hands of a kind Saviour: Jesus.

People

7.7 billion people
7.7 billion little kingdoms
Each beating heart its own story
Its own family photographs
Its own fancies
Each tiny life
Always leaving enough space
In each unfulfilled corner
For someone to come and fill the holes
Of the places we've been left unloved
Ever so needed to be held
By some present hands that do not let go
By a forgiveness that would see beyond
All of the times we've stuffed up
7.7 billion people
7 x 7 mistakes
Each counted themselves at one point
Or another
As unworthy of being loved
Straying away from their dismay
Through some kind of pointless distraction
Helpless distraction
7.7 billion people
And counting
All placed in the heart of God
Who became a man
Endured the cross
To flood our unfulfilled oceans
With unmerited grace
Undeserved mercy
With incomprehensible Love
Calling each unto their place of belonging:
His arms

Forgiveness

I will forgive you if you do me wrong once,
I will forgive you if you do me wrong twice.
I will forgive you if you do me wrong thrice.
If again you do me wrong, I will forgive you again and again,
for never, not once, did God not pardon me from something I did
wrong.

Gracious

Please be gracious with yourself.
For it was a bad decision,
that just might have seemed right at the time.
We both know,
that isn't the person you are today,
so you can let go of the mistakes you have made.

Change

You know in your heart what you want to do.
Don't burden yourself with the fear of change, of letting go.
Sometimes, some things, some people need to be let go
in order for you to truly *shine.*

Don't Be Stubborn

In the heartache you sought comfort, desiring to numb the pain you filled the hours of your day to keep your mind distracted. Time you thought would heal, only to find that when you were alone and the years had gone, the wounds of yesterday were still dripping of blood, so you longed to be held by another. Another you did find, but another did not come holding the blooming flowers of a new season that your heart so desires, only another distraction to ease the loneliness you feel within. An open closet you have not been in a long time, you do not let people gaze through your shelves anymore because you are afraid they will see the ugly you've hidden for so long. Hungry heart, don't feed your soul with garbage, your wounds will never heal that way. No longer do you need close yourself from the One you've always known will heal your treasured soul.

Boys

There it was, *finally*,
an addiction of mine dematerializing itself before my minds eye.
It was you, boy, boys.
I longed for tender affection from you for a long time,
too long.
I can not tell you with these words I am limited to how free I am
now.
But you, you proved to me something I felt to always be true,
that within you,
your flesh and bones that is,
I would *never* find what I was searching for.
I needed Jesus,
the answer my soul had been aching for,
Jesus.

Released

My petals aren't owned
by the men who abused me,
for Love has won me.

I Hope

I hope you felt loved today,

I hope you smiled today.

Wild One

She was a wild one, who knew within herself she was never made to settle for a nine to five job, for a man who didn't know how to love her, for an income that would merely sustain her. She was an adventurer, a barefooted wanderer, made to sail the seven seas with nothing but the wind carrying her, made to be loved by a love that would make her feel as though she's dancing on the clouds, made to be guided by the One who would help her decorate the sunshine garden that is her soul. So dance wild one, dance barefooted in the land of milk and honey.

You

Lost somewhere between her and him
Confined to nullify our dreams and unique ambitions of our
humanity
A robotic cleanse sweeping through this earth with everybody
looking exactly the same
Mechanical arms with hearts that do not know how to be rigid
Maybe that's why we are all confused
We are all following this way of living that is so far fetched from
our true identities
That not even the deepest parts of us know how to confine to.
This ridiculous life
How many times have you looked in the mirror and hated how
you looked?
How many times have you contemplated death?
How many times have you considered yourself incapable?
How many times have you enthroned yourself above others?
A selfish deceitful lifestyle
Each of us falling short in every aspect
With shallow proclamations of our own abilities
When we didn't even put the breath in our own lungs
The wind in the air, the sun in the sky
I know that none of you cause the stars to shine
If we take a closer look into all of humanity
And seriously observe each individual
We would see that we are all desperately weak
Desperately in need of one another, in need of *love.*
Entirely dependent on some kind of Orchestrator
Who puts the oxygen in our lungs
The animals on the land
Who causes the sky to bring forth its waters
Who speaks immortality to our mortality
Strength to our weakness
Purpose to our tiny lives
To our tiny jobs, our tiny homes
our tiny hands. our tiny funds,
our tiny years.

Strength

There is *Strength* in the heartache you feel,

there comes Strength from the God that made you.

Company

So I left,
because I was afraid that if I stayed long enough
I would be as good at faking a smile as you are.

Break

At times it's okay to give ourselves a break from certain people.

A Prayer

May there be a fire in your soul
that burns when the night is cold.

May there be a home in your heart
that stays if all others depart.

May there be great joys in your belly
that laughs even when nothing is funny.

May there be a willingness in your Spirit
that yields even if you don't feel like it.

May there be a Hope for your life
that you come to when things just don't seem right.

May this be a prayer for you,
a guide when you just don't know what to do.

Fire

Love will help you become the kind of fire that still
continues to burn on the coldest and darkest of nights.

Dear Reader,

To be honest, I am not entirely certain what to say to you at the conclusion of this chapter for I know that each of us have experienced some harrowing moments, and I know that the comfort that our souls so desperately need in these times will not merely come from these words I write to you.

The truth is, we are very feeble and extremely in need of help. Though, if you are anything like me, seeking help can be one awfully frightening task. Our hearts suddenly become bare before another and our weaknesses exposed; but help may be the only thing that gets you through, so I beseech you to seek help.

If you are intimate with the Maker of Heaven and Earth, I encourage you to not wait for this difficulty to pass until you attain joy, for I do believe that one of the very things He sent His Son for is for you to have the ability to, as corny as this may sound, dance in the storm (so let loose! Dance, sing, pour your heart out into the art of being alive).

If your heart does not belong to Jesus, then I would say to you, maybe the reason your hands hold this book is that you would find such Love; for in the chaos, void of God, I fear that there be no lasting hope for you. You will cling to time to help the wounds heal, but in time, when similar circumstances arise, you will find that the wounds are still there, just as fresh as they were. You may also cling to the earth, its sun, and its flowers but its aid is only temporal.

There is a lot of hope laid out for us, and if we are brave enough, we just might find it.

Yours Momentarily,
Bekky Briff.

Part IV

A Forgotten Art:
Seeking Help

Dear Reader,

One of the greatest downfalls I fear is enforced upon the generations is this senseless encouragement to be independent. It forces each individual to live carelessly for themselves or to be so isolated that when troubles arise we decide to be our own rocks, instead of humbly seeking help from another.

If we were made to be alone, I am certain we would each have a planet of our own, by ourselves, with our own personal rivers and oceans, but it just simply is not this way. For some reason, some great reason, you and I have been placed here, on this spinning, busy, wild globe, with many others who look very similar to you; each with a beating heart, blood, veins, a mind, each with their own families, their own troubles, their own successes; each alive for such a time as this.

You, sweet conqueror, luminescent in your very own way, I must tell you: There are some people that surround you for a very good reason. They are here to help you, here to celebrate your successes, here to hold the weight with you when the world seems too heavy, here to sing with you to your favourite song; here to wind down the window with you and feel the warmth of the summer sun, here to get wet with you and dance with you in the storm. Here, here, here, millions are here, and, so are you. So maybe you will be the friend who helps another, I encourage to do so - to ask, "are you okay?", to ask, "do you need help?", to ask, "can I dance with you?".

To the dreamers, the sleepers, the eaters, the doers, the business men, the business women, the hippies, the pirates, the pastors, the servants; to the bosses, the employees, the mothers, the fathers, the children, the sisters, the brothers, the lonely, the cleaners, the independent, to each of you with flesh and bones, may what you read in this chapter embolden you to seek help (we all know that you need it).

Yours Momentarily,
Bekky Briff.

Arise, Arise

Sorrow she grew burdensome upon the wake of my every day, she submerged me into a life of pity. Void of hope I slumbered into my bed, void of purpose I stayed in my bed. I stayed in my bed as long as I could, hopeful that someone would come to wake me, to revive me, to save me.

Once or twice I heard of a God, this God they told me resuscitates the dead to bring them back to life. I was sure I was basically dead, a dead body walking on legs with a beating heart and a flesh and bones that was well paralysed by the trauma. I had the courage once, just once, when I was deep into my sorrowful coma, to call out to this God. I knew nothing but to scream out his name, "Jesus", if my walls had ears I must have woke them from their sleep for they never heard me speak, for I had nothing good to speak about. I had nobody to call either for I had no loving family, no friends.

My room, she began to rain glitter, my body, I'm sure was floating; Sorrow, God knows what happened to Sorrow, I am not entirely sure where Sorrow went, but I am sure Sorrow left my room. I breathe, it is as though someone put my room next to the ocean breeze for the air had never been so fresh in here.

Jesus, the man whom I did not know, He came to help me. I am here, beating heart, flesh and bone, engulfed with courage, with purpose, with great love.

Seek Help, Before It's Too Late

I am the coldest here,
I dwell in the night with fear.
Too scared to reach out my hand,
too afraid to let you walk my land,
my land that is tattered and bruised,
misused by the ones who abused
my innocence.
Step back, you're getting too close, step back.
Alone, alone, alone, alone.
Nobody here, just me and my bones;
my bones that do not know how to carry
the burdens this world has tossed upon me.
I need, I need, I need, I need
ears that are not my own to hear my plead:
Help, I am suffocating. Here, I am suffocating,
I can not breathe. My bones are disintegrating.
How could I have been so foolish
to think that alone I could do this?

Unprepared

With the first steps of independence I hurried my heart to
bloom in a field that had no other flowers, so the spotlight could
be all on me. I wanted my petals to captivate even the smallest
of humans, and indeed, they did so. I stayed all summer long,
then watched the orange leaves fall and wither. I stayed into the
winter, then, I was confronted with the reality that I had made
my greatest mistake. I forgot that I could not keep warm on my
own, that here, in the cold, with the brisk winds of the winter,
I desperately needed another.

The Helper

A hundred machine guns, all blasting with their violence at once - that is how I would describe this nightmare. It is loud, it is violent, willing to obliterate anything and anyone in its way. I am in its way, its bullets, its ferocity marching toward me. I am empty handed, ill-equipped for any defence.

I turn my eyes to the sky, the great Spirit descends upon me, he defends me, he keeps me, he grants me peace amid the violence.

The violence is still here, louder, and most vicious than ever, yet I sit, still, breathing the air of serenity and hope, fully equipped for all defence. The great Spirit, Holy Spirit, guides me through it all.

Stay

You taught my vacating heart how to *stay.*

Ask

Sometimes our circumstances can be too hard,
too hard for our burdened hearts to know what to do with such
uncertainty. When we think that we know what we are doing,
when we feel confident in the circumstances we are given,
then suddenly not, we are found in the disdain of failure and
the, "this is not how I thought this would unfold."
We, in some kind of sense, come to the end of ourselves,
unable to comprehend up from down, success from failure.
In times of need we protect ourselves, we often run from the
ones who keep us safe, who we've always known we can trust.
Will we run and grow ever more weary, or will we let our knees
hit the ground, and ask for *help*?

Help

Humility shines at its greatest when a beat down soul reaches
out her hand and asks for help.

Her

I knew when I met her that what gave her feeble bones such magnificent strength is the courage that she always had to ask for help whenever she needed it.

Unfold

I unfold from the solace of her womb
To be met by an unfamiliar world
And it is now that I start growing old
Collecting moments to fill my life-room
Stories and objects to avoid my gloom
Is that a wrinkle? Am I fickle? It's cold.
Has anybody taught the world to hold?
Because its never held me in my doom

I watched a fire burn a building down
Mens labour destroyed in one swift moment
Where will the remnants of my life be found?
My frailty is in need of atonement
When my Spirit soon leaves this earthly gown
Will I have lived for my own enthronement?

I Need You

They had me convinced that I could soar on my own,
but I needed you.
(I still do)

When Suicide Came

I felt, amidst the dejected, dissected parts of my soul laying themselves bare, not knowing how to handle anymore, not knowing how to care; a still voice in the chaos of confusion speak to my soul, *"stay"*.

Wanted

YOU ARE WANTED HERE

One Night With Him

Festoons sparkle in the distance of the dawns blue, we were out
all night, the moon was following us, the stars, they were
chasing us, we were chasing the stars. White lines and bitumen,
we played all night, laying on country roads. I told Him about my
blues, He told me about his yellows. I was sad, He was happy. He
brought me a thousand smiles at dawn, enough smiles to make
me smile, enough smiles to make my insides smile. The sun
comes up, we welcome her presence; with the sun came hope,
with the brand new day came new beginnings. I untie my hair
from its messy bun, I breathe, taking in the air of the oceans
breeze. I don't feel sad anymore, one night with Him, and my
sadness hit the floor running, running far away from me.

Hearts Words

Words that should be spoken more: "I need help."

Vulnerability

Here's my heart,
I've put it on the table.
For you, my dear,
I'm stepping out of what's comfortable.

.

Speak Up

How are they meant to help you if they don't know?

Togetherness

Take me to the depths of your fears and let me pull you back up with me.

Another's Perspective

And if you let me,
I will show you that there is beauty written all over you.

Sisters

Upon the realisation of the weakest parts of me
I discovered that I need you
That if I could lay aside my pride
My unceasing punches of comparison
Then maybe I could lay upon you
Sister
Sisters
And let you help me carry these calamities
That I just can't handle on my own

In Need

I am in need of the comfort you bring, for my heart doesn't
always bear the solace I need.
I am in need of the warmth that you give, for my arms can't hold
me and keep me warm.
I am need of the sight that you have, for my eyes can not see
everything on my own.
I am in need of you, for I was never created to live this life all
alone.

Open

I open my heart for you to walk into, I open my fingers for you to entwine yours with, I open my lips and let you taste my skin. I built my walls so high that it made planet earth itself look nanoscopic, then you, you came along and completely obliterated my wall, made me realise that I was never made to do this on my own. I will never forget the day that you said, "If you were made to be alone, then nobody would be with you on this earth."

Bare

Take off my clothes,
strip me bare before the hands of the One who formed me.
Delve into my deepest parts where my heart can be unafraid,
unscathed by this world that hurt me.

Standing on the mountain tops I look to my past as a distant
memory,
here, it can not touch me.

Seen

Paper walls in the midnight walk, shattered glass on the concrete floor, I can hear everything going on behind your closed door. Secrets you try to keep, plastic smiles, plastic speech, how easy this image burns down that you're trying to give. How much longer are you going to hide the elephant in your room, when there are so many of us willing to help you?

So Does

Pain speaks, but so does Love and good friends.

Let Down Those Walls

In your little home, in the underground,
behind the two curtains that you have closed,
I peeked through a crack I found in your wall.
I did not think you would be this hard to watch,
as you squirmed in your own skin. As if it
was not good enough for you. Fear had you

as its puppet to play with, it had you.
Did it bury your tongue under the ground?
For I never heard you speak about it.
Were your lips sewn together, sealed and closed?
I did not know if I should be watching,
but I knew something changed behind your walls.

You kept hiding behind those walls,
but I would not allow fear to take you.
You are all tangled up in there. I watch
as its slimy hands throw you underground -
is this why you've pushed us away and closed
your heart? Did it make you afraid? Did it

convince you you're better off alone? It
is not clever, for it built the same walls
around me - no one was allowed too close.
Now, it is doing the same thing to you,
but its schemes did not keep me underground,
nor will it keep you. For my eyes have watched

it fool one too many of us. Now watch
me point out its deception. The way it
confines you and hides you under the ground,
convinces you no-one cares, builds a wall
around your heart, how it isolates you,
makes you think there's no way out. It closes

each door, *but the doors aren't locked,* they're just closed
you can walk out when you want, just to watch
the sun rise upon your heart. Fear has you,
but you can choose if it keeps you. For its
structure is shaky, they're just paper walls.
Fear's not clever. Come out from underground.

I have a secret for you, help is close -
under the ground help waits as it watches
you, longing for you to let down those walls.

If You Need Us

If you need our help, we will be right here.
Ready to get wet with you in the storm,
ready to hold you when you feel alone.
With comfort and love and our ears to hear
your sweet soul speak about all that you fear.
If you need us, just call us on your phone,
there's no need to go through this on your own,
Please, call on us, whether you're far or near.

Distance doesn't matter dear- we all need,
need help when our legs don't know how to stand.
When the trouble takes and takes with its greed,
we will not let it steal from you. You'll withstand
with help, remember, you need help. Indeed,
you're our friend, we'll do for you all we can.

.

They Might Not Know

If you need help let us know,
we might be *unaware* that you're hurting.

Dear Reader,

In a world that enthrones independence, trusting no-one, and being your own rock, I hope you find the audacity within yourself to defy this destructive way of living and learn, again, to depend upon Love, and also, your friends.

We desperately need each other, we need the warmth of a hug, the encouraging words, the different perspective; we need the hand that pulls us up when we're feeling low, or the hand that points us in the right direction when we do not know where to go. Sometimes, we actually have no clue what we are doing, and we can also be so short-sighted - it is in these times that we need each other the most.

Then, through all of this, we have the help of a very kind God, who teaches us to perfect the art of seeking help; who indeed nurtures us in the night when no one is around, who bottles each tear, who comforts us in a manner that empowers us to stand again - when everything else is telling to us to stay down.

So, if right now, you are confronted with trouble, I earnestly pray that Peace would come upon you - that in this moment you would, even though it makes absolutely no sense, experience joy. That your beautiful heart would know that you are not alone in this. For we are here, the girls from different places around the globe cheering you on - you've got this, but more than that, we've got this. Your victory is our very own, and your challenges, we walk through with you - please, tell us if you need us.

Yours Momentarily,
Bekky Brill

Now, this is almost the end of the book, upon this, there are just a few more things I need say to you...

...should your eyes desire to read on, please do.

Dear Reader,

If, by now, the words that you've read have helped you realise your weaknesses, and your inability to voyage the circumstances this earth yields alone, then this part of the book is specifically for you.

When I was 17 I reached out my hand to somebody my mind did not know it needed, but my heart was ever-so desperate for: Jesus. When I turned 18 I was baptised, I called it being dunked in the water for I did not see the point in being baptised, but something in my heart was telling me to do so - in obedience to the little voice in my heart, I let my best friend at the time, and my pastor, dunk me in the water, for I concluded that the worst thing that could happen is I would get wet (and wet I did get). My life, as I knew it, completely transfigured - I came out of the water uncontrollably laughing and crying. The next day I spent 10 hours weeping, I did not understand what was happening, but I knew it was God. That night, I prayed the best way my heart knew how, and I listened to worship music, then I felt God speak to my heart, "every inch of pain you carried, that's mine now," I felt this heavy weight lift off my shoulders, as he continued, "here is my peace, this is called to be yours forever." At this, my body was overcome with this sensational peace that I had never before encountered - not in drinking, boys, the ocean, or any sort of thing this world could offer me.

If you feel upon yourself this warm love, goosebumps, or maybe even a Peace that you have not known, Holy Spirit is upon you, letting you know that He is with you, revealing Himself to you. I believe that Jesus, Himself, is calling you. If you desire to respond to this, and turn away from the life that you have been living, then this is a moment for you to give your heart to Jesus through just a simple prayer - "Jesus, I am weak without you. My soul is in need of the Peace that you bring. I recognise and believe that you died and rose again for me - to make me like you, that you've forgiven me of my sins. I believe in you Jesus, as my Lord, as my King. Amen."

Should you have prayed this prayer - welcome to the family, you are safe here, and your heart will bloom as it never has. Please, if you did pray, let a friend know who is Christian, I would also love for you to email your experience to me: bekky@bekkybrillpoetry.com

Here's to your heart, shiney, new and completely free.

Yours Momentarily,
Bekky Brill.

Alive and Here

I am made from dust.
My heart, inside, beats.
My blood, a flowing river.
My spirit, a blooming flower.

Each curve, a little left of perfect (whatever that is).
Each wrinkle, a little too much saggy (whatever that is).
Each part of me, a little love from Jesus (He's got what I need).

Now I see what I lack - nothing,
I'm now complete.

Hear The Birds

Into the wilderness I ran, to hear the birds that sang.
They sang, they sang, and sang of my Maker's love for me.

1 John 4:7-16 (TPT)

Those who are loved by God, let his love continually pour from you to one another, because God is love. Everyone who loves is fathered by God and experiences an intimate knowledge of him. The one who doesn't love has yet to know God, for God is love. The light of God's love shined within us when he sent his matchless Son into the world so that we might live through him. This is love: He loved us long before we loved him. It was his love, not ours. He proved it by sending his Son to be the pleasing sacrificial offering to take away our sins.

Delightfully loved ones, if he loved us with such tremendous love, then "loving one another" should be our way of life! No one has ever gazed upon the fullness of God's splendor. But if we love one another, God makes his permanent home in us, and we make our permanent home in him, and his love is brought to its full expression in us. And he has given us his Spirit within us so that we can have the assurance that he lives in us and that we live in him.

Moreover, we have seen with our own eyes and can testify to the truth that Father God has sent his Son to be the Savior of the world. Those who give thanks that Jesus is the Son of God live in God, and God lives in them. We have come into an intimate experience with God's love, and we trust in the love he has for us.

The

End

CPSIA information can be obtained
at www.ICGtesting.com
Printed in the USA
LVHW070205070521
686681LV00022B/1214